A Pocket Dictionary of Greek and Roman

Gods AND *Goddesses*

Richard Woff

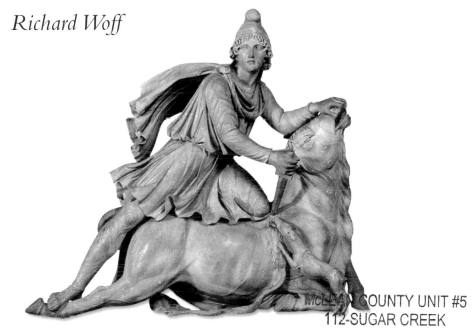

The J. Paul Getty Museum • Los Angeles

CONTENTS

© 2003 The British Museum

First published in 2003 by The British Museum Press, a division of The British Museum Company Ltd, London

First published in the United States of America in 2003 by
Getty Publications
1200 Getty Center Drive, Suite 500
Los Angeles, California 90049-1682
www.getty.edu

At Getty Publications:
Christopher Hudson, *Publisher*
Mark Greenberg, *Editor in Chief*
Agnes Anderson, *Jacket Designer*

Library of Congress Control Number:
2002116725

ISBN 0-89236-706-7

The Greeks and Romans had many gods in common. Where a god has two names in this book, the first is the Greek name.

THE TWELVE OLYMPIANS

Zeus/Jupiter 5

Hera/Juno 6

Poseidon/Neptune 7

Demeter/Ceres 8

Athena/Minerva 9

Apollo 10

Artemis/Diana 11

Aphrodite/Venus 12

Hephaestus/Vulcan 13

Ares/Mars 14

Hermes/Mercury 15

Dionysus/Bacchus 16

GODS OF LIVING AND DYING

Hades/Pluto 17

Persephone/Proserpina 18

Hecate 19

Hypnos and Thanatos 20

Hebe 21

Eros/Cupid 22

Asclepius/Aesculapius 23

GODS AMONG HUMANS

Iris 24

Heracles/Hercules 25

The Dioscuri 26

Nike/Victoria 27

The Muses 28

The Fates 29

THE NATURAL WORLD

The Horae or Seasons 30

The Charites or Graces 31

Helios/Sol and
Selene/Luna 32

Winds 33

Rivers 34

Eos/Aurora 35

Pan 36

Nymphs 37

The Master of Animals 38

PUBLIC AND PRIVATE

Hestia/Vesta 39

Lares and di Penates 40

Tyche/Fortuna 41

Janus 42

Kings and Emperors 43

FOREIGN GODS AND GODDESSES

Mithras 44

Cybele 45

Isis 46

The Christian God 47

Sarapis 48

A–Z List of Gods and Goddesses

Aeolus	33	Fortuna	41	Minerva	9
Aesculapius	23	Graces	31	Mithras	44
Aphrodite	12	Hades	17	Muses	28
Apollo	10	Hebe	21	Neptune	7
Ares	14	Hecate	19	Nike	27
Artemis	11	Helios	32	Nymphs	37
Asclepius	23	Hephaestus	13	Pan	36
Athena	9	Hera	6	Persephone	18
Alexander	43	Heracles	25	Pluto	17
Aurora	35	Hercules	25	Poseidon	7
Bacchus	16	Hermes	15	Proserpina	18
Boreas	33	Hestia	39	Rivers	34
Ceres	8	Horae	30	Sarapis	48
Charites	31	Hypnos	20	Seasons	30
Christian God	47	Iris	24	Selene	32
Cupid	22	Isis	46	Sol	32
Cybele	45	Janus	42	Thanatos	20
Demeter	8	Juno	6	Tyche	41
di Penates	40	Jupiter	5	Venus	12
Diana	11	Lares	40	Vesta	39
Dionysus	16	Luna	32	Victoria	27
Dioscuri	26	Mars	14	Vulcan	13
Eos	35	Master of Animals	38	Winds	33
Eros	22	Mercury	15	Zephyrus	33
Fates	29			Zeus	5

Zeus/Jupiter

Zeus was the head of the family of the gods and supreme ruler of both gods and humans. He had a special responsibility for justice. When an ancient Greek swore an oath, it was Zeus who made sure that the oath was not broken.

Originally, Zeus was a sky god who controlled the weather. For this reason his weapon was the thunderbolt, and his home was at the top of mountains, especially Mount Olympus.

In Greece, his most famous temple and statue were at Olympia where the Olympic Games were held in his honour every four years, starting in 776 BC. In Rome, he had the most magnificent and most important temple on the Capitoline Hill, which he shared with Juno and Minerva. Every year huge celebrations were held in his honour. Roman generals finished their triumphal parades by offering sacrifices in front of his temple.

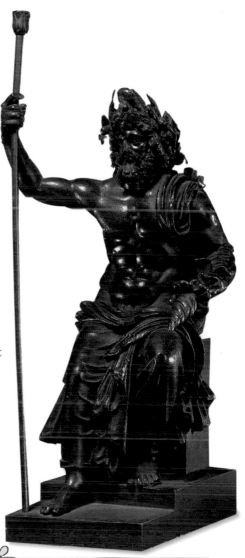

A bronze figurine of Jupiter holding his sceptre and a thunderbolt.

Hera/Juno

Hera was the queen of the gods and goddesses. She was both the sister and wife of Zeus. Several of the oldest temples in the Greek world belonged to her. In Rome she shared the most important temple in the city with Jupiter and Minerva.

Hera's special responsibility was to protect marriage. She was often shown lifting the marriage veil from her face. She became very angry when Zeus had love affairs with other goddesses and women, and fiercely persecuted the children of these affairs, for example, Heracles, Leto and Io. Hera turned Io into a heifer and sent a gadfly to sting her!

Hera was often associated with cows and sometimes with horses. She was the patron goddess of the city of Argos, near which she had a famous temple. Every year her priestess used to ride from the city to the temple in a cart pulled by cows and accompanied by all the unmarried girls.

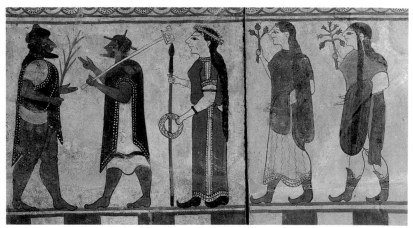

An Etruscan painting showing the Judgement of Paris. Hera is the goddess in the middle holding the plant with three stems.

Poseidon/Neptune

Zeus divided up the world between his brothers and sisters and gave rule of the sea to Poseidon.

Poseidon was a violent god of enormous strength. He drove his three-pronged trident into the earth to make earthquakes. Poseidon once shipwrecked Odysseus for blinding his son Polyphemus the Cyclops. Another time, Poseidon sent a bull from the sea to destroy a man named Hippolytus.

Poseidon was also closely associated with horses, which were sometimes sacrificed to him. He often changed shape into a horse, and one of his children was the winged horse Pegasus.

Poseidon competed unsuccessfully with Athena to be patron god of Athens and with Hera to be patron god of Argos, but many smaller towns and villages around the coast of Greece were named after him. At Corinth, the Greeks celebrated one of the greatest athletics competitions in his honour.

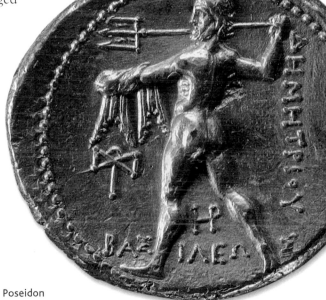

On this silver coin of a Macedonian king, Poseidon gets ready to throw his trident. The king wanted to commemorate his victory in a sea-battle.

Demeter/Ceres

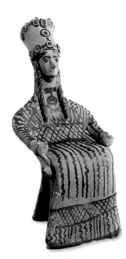

Demeter was the sister of Zeus and mother of Persephone. Her name includes the Greek word for 'mother' and an ancient word that probably means 'barley'. She was responsible for the growth of all plants and crops and especially of wheat. She taught humans how to plant seeds and grow wheat.

This clay figure may be Demeter or her daughter Persephone. She wears a high headdress and a pomegranate necklace.

Every year in the autumn, the ancient Greeks held a festival in honour of Demeter. Only women could take part, and they kept its rituals secret from men. We still know very little about what happened during the festival. We do know that it was intended to bring success to the sowing of seed.

In Rome, Ceres's temple and her festival in the spring were especially linked to the ordinary people of the city.

A marble statue from the temple of Demeter at Cnidus in Turkey.

Athena/Minerva

Athena was the favourite child of Zeus. She was born from the head of Zeus after he swallowed her mother Metis, a goddess of wisdom. Athena combined the cleverness and skill of her mother with the power of a male warrior. It was often Athena who enforced her father's rule and fought against his enemies.

Among her many inventions were weaving, horse bridles, and the *aulos* (a double pipe). She was the protectress of heroes such as Heracles and Perseus and especially Odysseus, who was so closely linked to her that he even used the name of her mother to trick the cyclops Polyphemus.

Athena was worshipped throughout the Greek world, but was specially connected to Athens, where numerous temples were built in her honour. Each year the people celebrated her birthday with gifts and a procession.

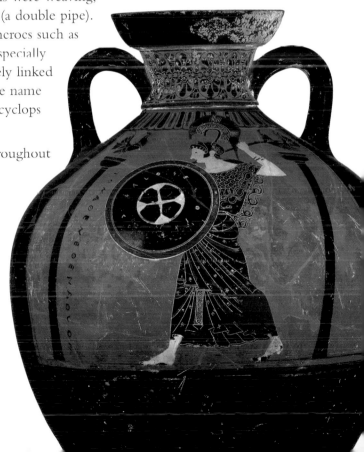

This pot, full of the finest olive oil, was a prize in an athletics festival in honour of Athena's birthday.

Apollo

Apollo was always shown as a beautiful youth. He was linked to the athletic and military training undertaken by well-born young Greek men. Apollo was also connected with music, especially the lyre.

Apollo's mother was Leto and his father was Zeus. While Leto was pregnant, Hera persecuted her until she finally gave birth to Apollo and his twin sister Artemis on the tiny island of Delos.

Apollo's weapon was a bow, with which he shot arrows of punishment and sickness at humans. He could also bring healing; sick people used to come to Delos looking for cures for their illnesses. He was also a god of prophecy. At his sanctuary at Delphi, his priestess used to answer visitors' questions about the future. Orestes came to Delphi after killing his mother, to find out how to escape the Furies who were chasing him.

At Rome, the Emperor Augustus adopted Apollo as his patron god.

A huge marble statue of Apollo from Cyrene in north Africa. He holds a lyre and looks down at a snake that has wrapped itself around his quiver of arrows.

Artemis/Diana

Artemis was a goddess of the wild and roamed the forests with the nymphs. She was both a hunter (her weapon was a bow) and a protector of animals.

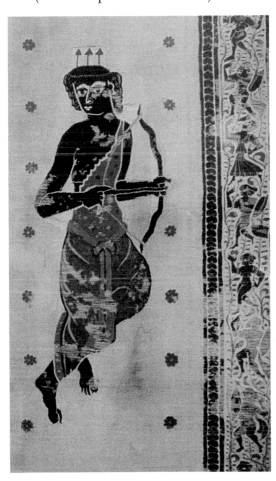

She was quick to anger and deadly in her punishment of those who offended her. One day, the hunter Actaeon came upon her by accident as she was bathing. Artemis turned him into a stag and he was torn apart by his own dogs. When the Greek king Agamemnon killed one of her deer, she demanded that he sacrifice his daughter to make up for it.

Artemis was a goddess of women and especially of the important moments in ancient Greek women's lives. She watched over girls as they went through the rituals at which they became women. Artemis attended to women in childbirth. If a woman died suddenly, the Greeks said that she had been struck by the arrows of Artemis.

This is part of a wall hanging made in Egypt in the 4th century AD. It shows Artemis with her bow.

Aphrodite/Venus

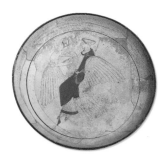

Aphrodite rides a goose across the inside of this drinking cup.

Aphrodite was the goddess of physical desire and sexual love. It was Aphrodite who made sure that the human race continued to reproduce itself through children. She had a great deal in common with fertility goddesses from the Near East. Her birthplace and home was Cyprus.

The beauty of Aphrodite was the cause of the Trojan War, yet she was married to Hephaestus, the least handsome of the gods. She had love affairs with Ares and with several mortal men including Anchises, a Trojan prince. After the destruction of Troy, Aeneas, the son of Aphrodite and Anchises, wandered all over the Mediterranean in search of a new home. He finally arrived in Italy. The Romans claimed they could trace their origins back to Venus through Aeneas. The family of Julius Caesar connected their name with Aeneas's son Iulus.

A marble statue of Aphrodite washing herself.

Hephaestus/Vulcan

Hephaestus was a god of fire. He was the least beautiful, but most skilful of the gods. He made bronze tripods that could move about on their own, robot watchdogs and golden serving women. His wife was Aphrodite, the most beautiful of the goddesses, but she was not faithful to him.

When Hephaestus was born, his mother Hera was so horrified at his crippled feet that she threw him from Mount Olympus. He was rescued by sea nymphs. He took his revenge on his mother by sending her a throne that would not let her stand up again once she had sat down. Eventually Dionysus got him drunk and convinced him to come back to Olympus where he freed Hera and took his place among the other gods.

His workshops were thought to lie beneath volcanoes. At his festival in Rome offerings of live fish were thrown into a fire to protect the lives of human beings.

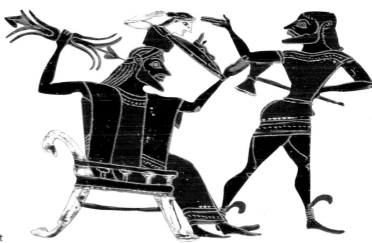

In this painting from a Greek wine-cup, Hephaestus has just cut open Zeus's head with his axe so that Athena can be born.

Ares/Mars

For the ancient Greeks, Ares was a fierce and violent god of war who brought disorder and destruction. He was the son of Zeus and Hera.

He had a love affair with Aphrodite, the wife of his brother Hephaestus, and they had children including Eros, Deimos (Panic), and Phobos (Fear). One story tells how Hephaestus trapped Ares and Aphrodite in a net while they were making love and only released them after the rest of the gods had had a chance to laugh at them.

In Rome, Mars was a very important god. He was the father of Romulus and Remus, who founded the first city of Rome. Roman generals carried out complicated rituals in honour of Mars before they set out for war. The Emperor Augustus linked himself with Mars Ultor (The Avenger) when he defeated the assassins of his father, Julius Caesar.

This bronze statuette of Mars is Roman. It shows the god wearing a fine breastplate.

Hermes/Mercury

Hermes was the son of Zeus and a nymph. He took messages from gods to humans, guided the souls of the dead to the Underworld, and escorted gods and humans to their destinations. He usually wore a broad-brimmed travelling hat, which sometimes had wings. His winged boots helped him move quickly and he carried a special staff.

On the day of his birth Hermes invented the lyre and stole some of Apollo's cattle by leading them backwards, to confuse those searching for them. When Apollo found the cattle, Hermes soothed his anger by giving him the lyre, but stole his bow and arrows at the same time!

He was very friendly towards humans. A statue of Hermes stood at the door of most Greek houses to protect the people coming and going. In Greece and Rome, he brought success to herds of animals and to businesses of all sorts. He was also the patron god of thieves.

Mercury stands in the middle of this Roman silver plate from France. Notice his staff and the ram on the left.

Dionysus/Bacchus

Dionysus was the son of Zeus and a mortal woman. He was a god of growth and change and was especially connected with wine. He discovered that wine could be made from grapes and he gave this gift to humans. Whenever anyone drank wine, they paid their respects to Dionysus.

Dionysus was one of the most important gods to human beings. There were many festivals in his honour and most of these involved drinking and wild behaviour. His worshippers became possessed by Dionysus either through wine or because he had entered their minds.

In Athens, theatre competitions were held in his honour, to which most of the people of the city came. One Athenian play tells the story of Dionysus' arrival in the city of Thebes. He is rudely rejected by the king. The god then sends the Theban women mad, and they tear the king to pieces with their bare hands.

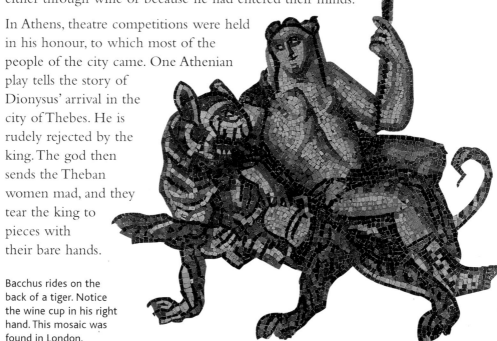

Bacchus rides on the back of a tiger. Notice the wine cup in his right hand. This mosaic was found in London.

Hades/Pluto

Hades was the only one of Zeus's brothers and sisters who did not live on Mount Olympus. Instead, he ruled over the land of the dead, which was also called Hades, and whose entrance was at Lake Avernus in Italy.

Hades was a pitiless ruler who very rarely allowed anyone to return from his kingdom. One exception was Eurydice, who had died from a snake bite. Her husband, Orpheus, was a magical musician, and he charmed Hades into letting him take Eurydice back as long as he did not look at her until they had reached the upper world. Orpheus was unable to resist a glance at his wife and in so doing lost her forever.

Hades' name meant 'the invisible one', and the Greeks avoided mentioning him by name. They invented other names for him such as 'the rich one', which is what his Roman name, Pluto, means in Greek.

Hades and his wife Persephone on the inside of an Athenian wine cup. Imagine what the drinker was meant to think as he saw the god of the dead emerge from the wine ...

17

Persephone/Proserpina

Persephone was the daughter of Zeus and Demeter. She was kidnapped by Hades and carried off to the land of the dead to be his wife. Demeter searched for her daughter all over the world and neglected her duty to make things grow. Finally Zeus intervened and arranged for Persephone to return. However, Hades tricked Persephone into eating some pomegranate seeds, which meant that she had to spend part of each year back in the land of the dead.

This story is clearly linked with the cycle of the seasons: in autumn and winter Persephone was absent from the world, and all things died; in spring and summer she returned, and the world came to life again.

Worship of Persephone and Demeter offered the possibility of a better life after death. Many Greeks took part in secret rituals in their honour. The most famous of these took place at Eleusis, a town near Athens.

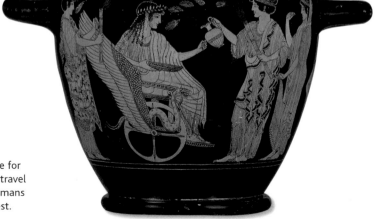

Persephone pours wine for Triptolemos, who will travel the world teaching humans how to sow and harvest.

Hecate

Hecate was a cousin of Artemis. In early Greek times she was very powerful and granted human beings success in all sorts of activities, from war to fishing. She always kept this power for doing good, but gradually also became known as a frightening goddess of witches and magic.

She was commonly worshipped at crossroads. People left special food for her there: fishes, cakes decorated with lit torches, and sacrificed puppies. Sometimes she appeared there, accompanied by strange dogs that howled in the night. Her statues usually had three faces or bodies so that they could look in different directions.

Like Artemis, Hecate looked after women in childbirth, and she was very kind to Demeter when she was searching for Persephone. If a Greek needed to use a spell or curse in order to get what they wanted, they called on Hecate to help them.

On this wine jug Hecate approaches an altar. We can tell it is night time as she carries lit torches.

Hypnos and Thanatos

Sleep (Hypnos) and Death (Thanatos) were brothers. They were the children of Night, one of the most ancient goddesses. Both brothers were winged, and Sleep carried a horn from which he poured the gentle liquid that brought sleep to humans. Greek artists showed them lifting up dead warriors from the battlefield and carrying them away. Sleep was usually at the head and Death at the feet.

This oil jar was made to be placed in or on a grave, like the one you can see in the painting.

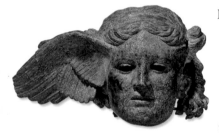

This bronze head of Hypnos is a Roman version of a Greek sculpture.

During his travels, Heracles came to a city where the king had been told he was about to die. The king had asked for someone to take his place, but only his beloved wife had agreed to do it. The king had allowed his wife to die instead of him. However, when Death came to claim her, Heracles defeated him in a wrestling match and brought the queen back to her husband.

Hebe

Hebe was the goddess of youth. She was a daughter of Zeus and Hera and served her father with wine at the banquets of the gods. Hebe prepared Athena's chariot for her when she set out for war against the Trojans.

When Heracles became a god, Hera granted him Hebe as his wife. This was a symbol of Hera's reconciliation with Heracles, whom she hated because he was one of Zeus's children by a mortal woman.

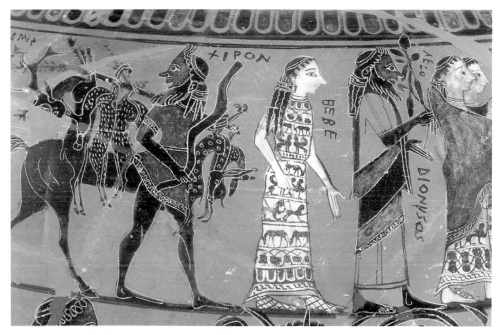

Wearing a splendid dress, Hebe is on her way to a wedding. Ahead of her are other guests including Dionysus and Leto, mother of Apollo and Artemis.

Eros/Cupid

Eros was the son of Aphrodite and Ares. It was Eros who made gods and humans fall in love, even when they did not want to. He was usually shown with wings and was armed with a bow and arrows, which he shot at those he wanted to attract to each other. He was cruel and cunning, but the Greeks realized that he brought great pleasure as well as pain.

In the Roman world, Cupid often appeared in art as a playful, chubby toddler. Some ancient thinkers saw him as the power that lay behind the creation of all things and that held the different parts of the universe together.

This bronze statuette of Cupid was found in eastern France. He was originally carrying something, probably his bow.

In this drawing, made in 1866 by Edward Burne Jones, Cupid sees and falls in love with the sleeping Psyche.

Asclepius/Aesculapius

Asclepius was the son of Apollo and a mortal woman. Apollo destroyed his mother for being unfaithful, but rescued the unborn Asclepius. When he grew up, Asclepius learned the arts of healing and medicine.

People came to Asclepius's temples to seek cures for all sorts of illnesses. His most famous temples were at Epidaurus, where there is still a magnificent theatre, and on the island of Cos, home of the famous doctor Hippocrates. The Romans summoned Asclepius to Rome to help with a plague and built him a temple on an island in the River Tiber.

Asclepius carried a staff that often had a snake coiled around it. This has become the symbol of doctors all round the world. Eventually, he tested his powers too far and brought back to life one of Artemis's favourite followers. Zeus would not allow the rules of death to be broken and destroyed Asclepius with a thunderbolt.

A marble head of Asclepius from the island of Melos. The statue was originally much bigger than life-size and probably stood in a temple.

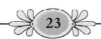

Iris

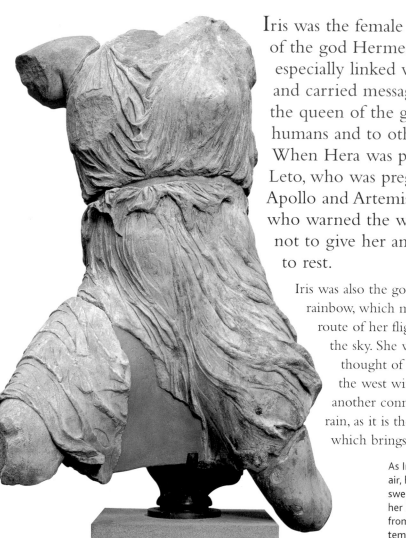

Iris was the female equivalent of the god Hermes. She was especially linked with Hera and carried messages from the queen of the gods to humans and to other gods. When Hera was persecuting Leto, who was pregnant with Apollo and Artemis, it was Iris who warned the whole world not to give her anywhere to rest.

Iris was also the goddess of the rainbow, which marked the route of her flight through the sky. She was sometimes thought of as the wife of the west wind – this is another connection with rain, as it is the west wind which brings the rain.

As Iris flies through the air, her clothes are swept back and against her body. This figure is from the Parthenon temple in Athens.

Heracles/Hercules

Heracles was the only mortal to become a god. He earned this honour through the completion of a series of labours set for him by the goddess Hera. She hated Heracles because he was the son of her husband Zeus by a mortal woman. At the end of his labours, Heracles was brought to Olympus by Athena and reconciled with Hera.

As a great hero, Heracles was honoured in a large number of local regions throughout Greece, and many cities gained prestige for themselves by creating links with one or other of his labours. The Romans claimed that he had had an adventure on the site of their city.

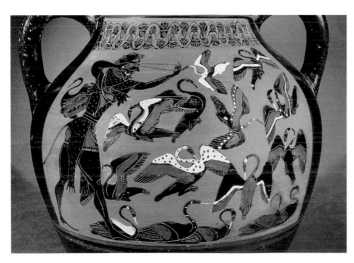

Alexander the Great claimed to be a descendant of Heracles and even featured the hero's head on his coins. In Rome, some of the later emperors, for example Commodus, also likened themselves to Heracles and had themselves shown wearing his lionskin.

In this painting from a pot, Heracles is using a sling instead of his bow and club to kill some fierce, flesh eating birds

The Dioscuri

In a battle or during a storm at sea, an ancient Greek might call for help from the Dioscuri, Castor and Pollux, the twin sons of Zeus. Pollux was a warrior, Castor a boxer. They were both skilled horse riders. In one battle, they helped the Roman army to win and rode back to Rome to announce the victory. At sea, they appeared as peaks of flame at the tips of masts. We know this as St Elmo's Fire.

Their friendliness towards humans was shown in their worship. This often involved laying tables with food and wine so that the twins could share a meal with their worshippers.

The Dioscuri also had a human father, which meant Castor was mortal and Pollux immortal. On their final adventure, Castor was killed, but Pollux asked Zeus to allow them to share death. As a result, they spent alternate days on Mount Olympus and in the land of the dead.

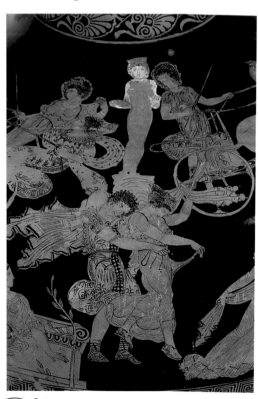

This pot painting shows the twin brothers carrying off the daughters of a king to be their brides. Their getaway chariots are waiting.

Nike/Victoria

Nike was the goddess of victory. Sometimes she was linked to one of the greater deities; for example, there is a temple of Athena Nike on the Acropolis at Athens.

Usually, Nike had wings and was shown flying or landing. The huge gold and ivory statues of Athena in the Parthenon and of Zeus at Olympia showed Nike landing on their outstretched hands.

She honoured individuals who had won competitions in athletics, theatre or music and also cities and states that had won battles or wars.

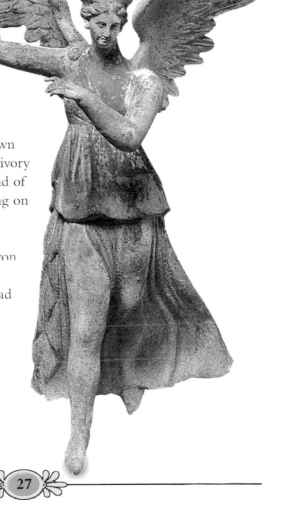

A terracotta figurine of Nike, from Turkey. She has large powerful wings and her clothes flutter in the breeze as she lands.

The Muses

The Muses were the daughters of Zeus and Mnemosyne, goddess of memory. From their mother, they learned everything that there was to know so that poets, writers and musicians turned to them for knowledge and inspiration. They enabled kings to master words so that they could settle arguments and bring peace.

The most famous home of the Muses was Mount Helicon in central Greece. They may originally have been water goddesses; some springs and streams in Greece were thought to inspire poets if they drank from them. They could also punish poets; for example, they blinded one poet for his boasting.

Not everyone agreed how many Muses there were, but eventually it became accepted that there were nine. In places where they were worshipped, the Greeks sometimes put up a building containing a library or statues of poets. Such a building was called a Museum.

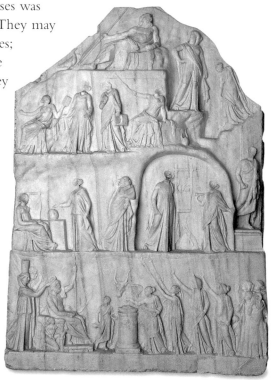

The Muses can be seen on the upper levels of this marble sculpture. At the bottom left sits the poet Homer, who is being made into a god.

The Fates

The Fates were the children of Night and were some of the oldest Greek deities. Between them they determined all that would happen to gods and to mortals. The Fates stood for the order of the universe. It was within Zeus's power to change what had been decided, but he preferred to keep order in case changing one thing should bring chaos.

There were three Fates: Clotho, Lachesis, and Atropos. The Greeks thought of them as women spinning the thread of human life. Clotho spun the thread, Lachesis measured its length, and Atropos cut it.

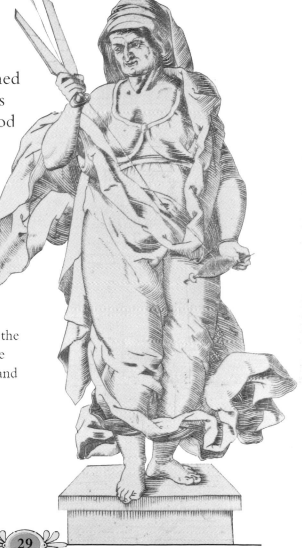

This picture of Atropos was engraved on the back of a large clock made in Strasbourg in 1589. She is about to cut the thread of life with her shears.

The Horae or Seasons

There could be two, three, or four Horae in ancient Greece. This was because in the Mediterranean region the differences between four distinct seasons are much less clear than they are in northern Europe or North America.

The Horae were not important goddesses to the Greeks, but because the seasons come in a fixed order year after year after year, the Horae demonstrated that the world was a place of order under the control of the gods.

They were the daughters of Zeus and Themis and were often present at the birth or marriage of gods and goddesses. They also guarded the gates of Mount Olympus. In the *Iliad* Homer says, 'The great sky and Olympus are entrusted to them, either to open up or close the gates of dense cloud.'

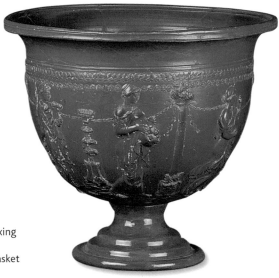

A Roman bowl for mixing wine. In the centre is Autumn, carrying a basket of fruit.

The Charites or Graces

The three Charites were daughters of Zeus. Originally they were goddesses of plants and growth; they were closely linked with roses, myrtle and spring flowers. They came to be generally associated with charm and loveliness.

Like their half-sisters, the Horae, they attended events in the lives of the gods, such as weddings. In the *Odyssey* Homer explains how the Charites bathe the goddess Aphrodite, anoint her with oil, and then dress her in lovely clothes.

In some stories, the god Hephaestus was married to one of the Charites. In this way, the ancient Greeks could begin to explain the combination of beauty and skilful hard work that can be seen in arts and crafts.

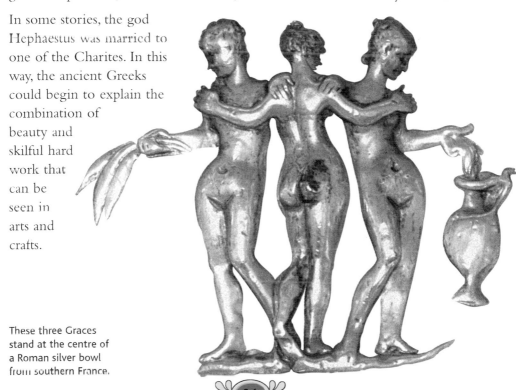

These three Graces stand at the centre of a Roman silver bowl from southern France.

Helios/Sol and Selene/Luna

Helios was the sun god. He drove a four-horse chariot across the sky from east to west. He then travelled back at night in a golden cup along the river of Oceanus that surrounds the world. His sister, Selene, was the Moon. She drove a chariot pulled by two horses or sometimes oxen.

The Greeks paid respects to the sun and moon, but did not worship them. Aristophanes, the Athenian playwright, said that this distinguished the Greeks from barbarian foreigners.

In Rome, in the third century AD, Sol became for a time the most important of the gods.

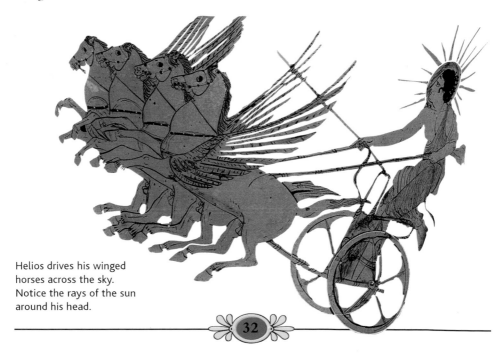

Helios drives his winged horses across the sky. Notice the rays of the sun around his head.

Winds

According to Homer, the guardian of the winds was Aeolus, who kept them fastened up in a bag. However, the Greeks also at times thought of the winds as gods and carried out ceremonies either to calm them down or to ask for gentle breezes. They usually carried out these ceremonies on hilltops.

Wind gods could be male or female, but the four main winds were all male. In 480 BC, Boreas (the north wind) wrecked the fleet that was accompanying the invading army of the Persian king Xerxes. Even the gentle Zephyrus (the west wind) could be dangerous, as he caused the death of Apollo's lover by blowing a discus off course.

There were many stories of winds carrying off young men and women. Boreas, for example, carried off an Athenian princess to be his wife. It is likely that the wind symbolized death in these stories.

This oil pot from Corinth probably shows a wind god. He rushes across the pot, wings outstretched, scattering everything in his path.

Rivers

Greek river gods were always male. The best known was Achelous, god of the longest river in Greece. He competed with Heracles to marry Deianeira, but Heracles defeated him in a wrestling match.

River gods were often thought of as bulls or horses or as humans who had some features of bulls. In their fight, Heracles broke off one of Achelous's horns. Sculptors and other artists sometimes showed river gods as lying propped up on their elbows. This was very suitable for the idea of a river flowing. Sculptors found them convenient for filling the corners of pediments (the shallow triangular spaces at the ends of the roofs of buildings).

In certain situations, both the Greeks and the Romans made sacrifices to rivers, offered up prayers to them, and carried out rituals alongside them.

This marble figure is from the narrow corner of the pediment of the Parthenon temple in Athens. It is probably the Athenian river Ilissos.

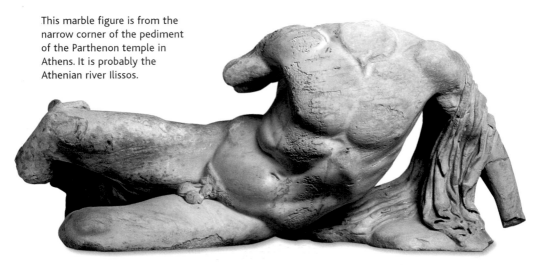

Eos/Aurora

Eos was the goddess of Dawn. In her two-horse chariot she rose into the sky ahead of Helios in his four-horse chariot. She was the mother of the winds and had affairs with several mortal men, none of which were successful.

In art she was usually shown with wings, pursuing one of her young lovers in order to carry him away to the west. This was probably a metaphor for death.

She asked Zeus for eternal life for one of her lovers named Tithonus. Unfortunately she forgot to ask for eternal youth, and so he grew older and older until he shrivelled up into a cicada. Tithonus was the father of her son Memnon, who became king of the Ethiopians and was killed by Achilles during the Trojan War.

This terracotta plaque, found on the island of Rhodes, shows Eos carrying off a young man as her lover.

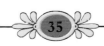

Pan

Pan was the son of Hermes and one of the Nymphs. He was the guardian of flocks of sheep and goats and also protected the shepherds. The Greeks usually worshipped him in caves, but he was also respected in towns. He was very popular with the Athenians because he helped them to defeat the Persians at the battle of Marathon.

This is a detail from a Roman silver platter. Pan carries his shepherd's rod and plays the panpipes.

His appearance was half-human and half-goat. He lived along with the Nymphs in wild places such as mountains and forests. When the Greeks visited wild areas, they were often anxious in case they met Pan unexpectedly; the sight of him could send a person mad with terror. We get the English word 'panic' from his name.

He was also famous for playing the panpipes, which are still popular in many countries today.

Nymphs

For the ancient Greeks, the natural world was full of gods and goddesses. Every river and stream, every mountain and often individual trees had their own goddesses. In the sea lived the daughters of the important sea gods. All these minor goddesses were the Nymphs.

The Nymphs were always young and beautiful and were the companions of goddesses such as Artemis and Aphrodite. Both gods and humans often fell in love with them.

Although they were not powerful goddesses, it was important to respect them. One human, named Erysichthon, cut down a grove of trees, ignoring the pleas of the nymphs who lived in them. Demeter punished him by making him always hungry so that no matter how much he ate, he was never satisfied. Finally, he went mad and ate himself.

Peleus tries to grab the sea-nymph Thetis, who changes into a sea serpent and bites his leg. Other nymphs run away in terror. The child of Peleus and Thetis was the Greek hero Achilles.

The Master of Animals

This gold pendant was made by a Cretan jeweller around 1700 BC. It shows a human figure in the centre wearing a high headdress. Two snakes rise from either side of him. He strides through a field of lotus flowers and in each hand he grasps a bird by the neck. These details show his control over nature.

Archaeologists have found several examples of this sort of figure and even more where the figure is female rather than male. The female figures often grasp lions or deer instead of birds. The figures seem to be powerful gods and goddesses of nature and are called the Master or Mistress of Animals.

The pendant was found on the Greek island of Aegina along with other fine pieces of gold jewellery.

Although this pendant was made in Crete, it was found on an island just off the coast of mainland Greece. Very similar images come from Egypt, Syria, and other parts of the Near East. They show the connections and exchange of ideas between the Greek world and other parts of the Mediterranean.

Hestia/Vesta

Hestia was the sister of Zeus and goddess of the fireplace. In ancient Greece, home life depended on the fire, which gave warmth and light to the house and over which food was

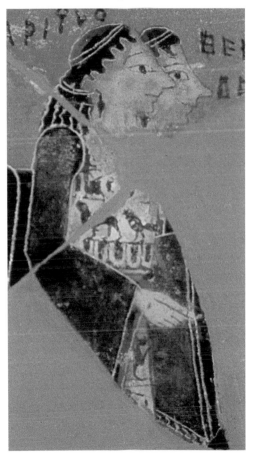

cooked. Newborn children were carried round the fireplace to symbolize their acceptance into the family.

Many cities also had fires that stood for the life and well-being of the whole city. Hestia looked after these fires too.

In Rome, she had a circular temple in the forum where the eternal fire of Rome burned. A group of unmarried women called the Vestal Virgins looked after her worship. The women had to devote their lives to Vesta for thirty years. If any one of them broke her oath to the goddess, it was a terrible scandal, and her punishment was to be buried alive.

Hestia on her way to the wedding of Peleus and Thetis (see Nymphs). She wears a dark cloak over her highly decorated dress. Alongside her is Demeter.

Lares and di Penates

Households in ancient Rome had two sets of their own gods who looked after their well-being.

The Lares were connected with the ancestors of the family and may even have been ghosts of dead family members. Most houses contained a shrine called a *lararium* where the family made offerings of food or wine every day. Outside the house, Lares were associated with crossroads. The di Penates looked after the spaces within the house itself.

The city of Rome also had its own Lares and di Penates who were guardians of the Roman state and government.

This bronze Lar carries a bowl to pour an offering of wine and, in his right hand, a special wine jug in the shape of a dolphin.

Tyche/Fortuna

Tyche was the goddess of chance. In the fourth and third centuries BC, as people grew doubtful about the value of public worship of the Olympian gods, Tyche became popular throughout the Greek world. She was goddess of the uncertainties of being human and could turn to the good or to the bad. In spite of this, she was often seen as a guardian of cities.

The Romans regarded Fortuna as a very important goddess. She had a public side that influenced the fortunes of the city, and a private side that affected whether women gave birth to children successfully. At Praeneste, to the south of Rome, Fortuna had a huge temple in the largest sanctuary area in the whole of Italy. Worship of Fortuna was known there for more than 600 years.

Tyche wears a crown of city walls. This is a small bronze version of a huge statue of Tyche made for the city of Antioch in Roman Syria.

Janus

Janus had two faces: one looked to the future and the other to the past. He was the Roman god of beginnings. He was especially worshipped at the start of each year and gave his name to the first month of the year.

The doors of his temple in the forum at Rome were never closed except when Rome was at peace everywhere. Until the reign of Augustus, the doors had been closed only once since the founding of the city more than 700 years earlier. Augustus had the doors closed three times and used this as a symbol of his rule. Under later emperors, the doors were closed more frequently.

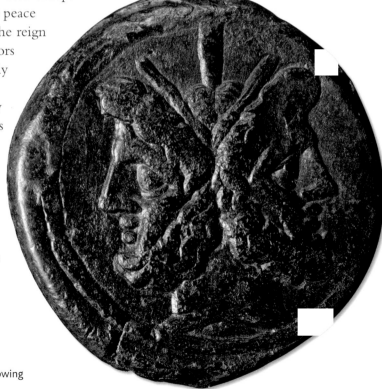

A Roman bronze coin showing the two faces of Janus.

Kings and Emperors

Although individual Greek cities often honoured early kings as heroes, the Greeks did not worship their rulers as gods. Alexander the Great was the first to introduce the idea to Greece. After Alexander's death, kings of Greek cities in the east were frequently regarded as gods and had their statues placed in temples alongside those of the other gods.

In Rome, there was a tradition that great men could receive honours as gods after death, and Julius Caesar was made into a god in 42 BC. The first emperor, Augustus, only permitted himself to be regarded as a god in places where people were already used to worshipping their rulers as gods. Although he traced his family back to the goddess Venus, Augustus was not worshipped as a god in Italy and the western empire until after his death. Later emperors came to be worshipped during their lifetime all over the empire.

This silver coin from Turkey shows Alexander the Great. He wears the horns of the Egyptian god Amun.

Mithras

Mithras was originally a Persian god. He was a sun god who carried out a number of tasks. One of these involved killing a bull along with the help of a dog, raven, snake, and two human companions. As it died, a stem of wheat sprang from the bull's spine and a grapevine from its blood.

His worshippers were men, who met in small groups and worshipped him in caves or buildings that resembled caves. Here they said prayers, heard stories of Mithras, and held feasts. Many of these buildings have been found, including one on Hadrian's wall and another in the city of London.

Mithras appealed to all classes of men and especially to soldiers who spread his worship all over the western Roman Empire. Eventually his worship gave way to Christianity, which appealed to the same types of men, and also to women.

Mithras kills the bull. You can see the dog and snake licking its blood.

Cybele

Originally Cybele came from Anatolia, a mountainous region in what is now Turkey. She was a great mother goddess who governed nature, brought healing and fertility, and gave information about the future. She was often shown riding in a chariot drawn by lions and wore a crown of towers showing that she brought protection to cities and towns.

She was worshipped widely in the Roman world, especially in Gaul and Africa. In 204 BC the Roman Senate voted that a temple to Cybele should be built on the Palatine hill. A great festival in her honour was held every March with a procession, fasting, bathing and finally feasting. Her power was so great that her worshippers became possessed by the goddess. Her priests even mutilated their bodies without feeling pain.

In a special sacrifice to Cybele, one of her priests climbed into a pit. A bull was then killed over the pit, and the priest bathed in its blood.

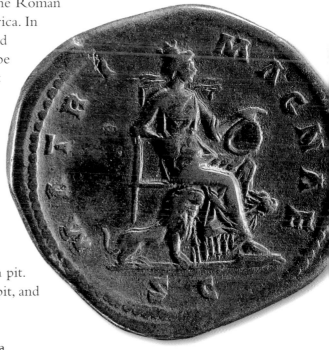

This bronze coin of the Roman Emperor Marcus Aurelius shows Cybele seated on a throne with her lion at her side. The words say 'To the Great Mother'.

Isis

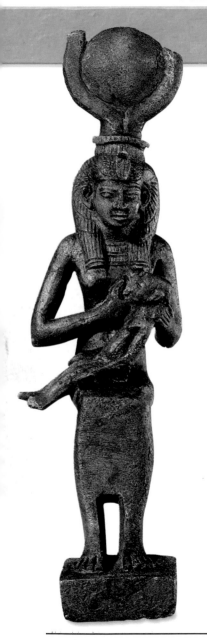

Isis was one of the most important Egyptian goddesses. She was worshipped because she brought new life. It was Isis who restored her brother Osiris to life after he was murdered. She also brought the annual Nile flood that made the land of Egypt fertile for growing crops.

After the Greeks and then the Romans conquered Egypt, her worship spread widely. There were temples of Isis in Athens and Pompeii and probably even in London.

The priests of Isis wore white robes and shaved their heads. Ordinary people could also join a special group of followers. In order to do so, they went through a series of rituals that included being washed, fasting, and having special secrets revealed to them. Like other foreign gods, Isis gave her followers hope of a life after death that offered something more than traditional Greek and Roman religion.

This bronze statuette shows Isis with her son Horus. It was made in Egypt at a time when Egypt was ruled by Greek kings.

The Christian God

Christianity began in the Roman province of Judaea in the first century AD. In the fourth century AD, under the Emperor Constantine, it became the official religion of the Roman Empire.

The earliest Christians probably saw Jesus as a holy man whose teachings offered an alternative view of traditional Jewish beliefs. As their ideas developed, Christianity became a fully established religion and Jesus became one of the three aspects of a single God.

For Christians, God was all-powerful, but also loved human beings in a way that Greek and Roman gods did not. God was never absent from the world. He took part in every aspect of their lives no matter how small, and promised those who believed in him life after death. For this reason, Christians were not willing to accept other gods, including the Roman emperor. This caused Christians to be persecuted by the Roman authorities.

This Roman mosaic from Hinton St Mary in Dorset is probably the earliest picture of Jesus anywhere in the world.

Sarapis

Sarapis was invented by the first Greek ruler of Egypt, whose name was Ptolemy. Ptolemy wanted to combine aspects of Greek and Egyptian gods in a single deity. From Egypt he took aspects of Osiris and Apis, the sacred bull of Ptah, and from Greece he took aspects of Zeus, Hades, Helios, Dionysus and Asclepius. Ptolemy named this new god Sarapis.

Sarapis was linked with the growth of wheat. His statues show him carrying a wheat basket on his head. He was also connected with the underworld and with healing. Like Apollo, another healing god, he had a temple on the island of Delos.

Worshippers of Sarapis could become members of special groups who met to feast and honour the god. In the Roman world, he was often associated with Jupiter and was adopted by some Roman emperors as support for their royal power.

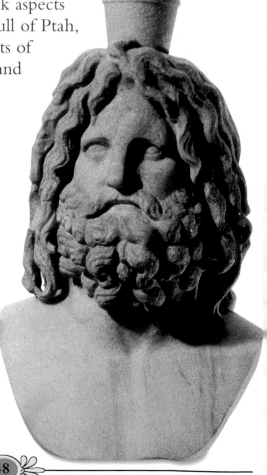

This marble sculpture of Sarapis shows clearly his similarities to Zeus and Asclepius. Notice the wheat basket on his head.